...and there in a clearing
stood a quaint little house...

"SKETCH BOOK"

WALT DISNEY

APPLEWOOD BOOKS

Distributed by The Globe Pequot Press

ISBN: 1-55709-207-9
Collector's Edition ISBN: 1-55709-208-7

First printing.

Thank you for purchasing an Applewood Book.
Applewood reprints America's lively classics—books from the past
which are still of interest to modern readers—on subjects such as
cooking, gardening, money, travel, nature, sports, and history.
Applewood Books are distributed by The Globe Pequot Press of Old
Saybrook, CT. For a free copy of our current catalog, please write to
Applewood Books, c/o The Globe Pequot Press, 6 Business Park Road,
P.O. Box 833, Old Saybrook, CT 06475-0833.

10 9 8 7 6 5 4 3 2 1

Library of Congress Cataloging-in-Publication Data
Disney, Walt, 1901-1966.
 ["Sketchbook."]
 Walt Disney's sketch-book of Snow White and the Seven Dwarfs.
 p. cm.
 Originally published: "Sketchbook." London: W. Collins, 1938.
 ISBN 1-55709-207-9 : $29.95. — ISBN 1-55709-208-7 : $100.00
 1. Disney, Walt, 1901-1966 — Notebooks, sketchbooks, etc.
 2. Artists' preparatory studies—United States. 3. Snow White and
the seven dwarfs. [Filmstrip] I. Title. II. Title: Sketchbook of
Snow White and the Seven Dwarfs.
NC1766.U52D52 1993
741.5'8'092—dc20 93-16898
 CIP

DEDICATED TO
THE ETERNAL SPIRIT
OF CHILDHOOD
IN ALL OF US.

ONCE upon a time the Brothers Grimm wrote the story of "Snow White and the Seven Dwarfs," a story destined to take an honored place in the folklore of the world.

In the summer of 1934 this famous fairy story caught the imagination of Walt Disney, who immediately began to invest the tale and its characters with his own genius.

The result, four years afterwards, was the first full-length cartoon film ever made. But the labor entailed by four years' work on this famous story makes a real-life fairy story of its own.

The seemingly insuperable technical difficulties have often been described. This book, however, takes the reader for the first time into the sacred precincts of Walt Disney's Hollywood studio, where the actual work of creating the characters was carried out.

It reveals how Walt Disney transformed seven identical dwarfs into seven individual "little men;" how each dwarf was slowly evolved; how each was endowed with distinctive idiosyncrasies; how, by adhering to a fundamental design for each dwarf, they were enabled to maintain their individuality throughout the film.

Walt Disney's Sketch Book lifts the veil from a branch of modern art about which little has been known.

"Snow White"

— Costume
and
Construction —

FEEL FOLD
OF COLLAR
AROUND
NECK

COLLAR
WRINKLES OR
FOLDS —

BOW
ADJUSTS
ITSELF TO
COLLAR —
OVER OR
UNDER—
WHICHEVER
LOOKS BEST

WAIST STITCHED
ONTO SKIRT

BACK OF
SKIRT IN
DARKER
TONE —

STITCH
EFFECT ON
PATCHES

PATCHES
CONFORM TO
FOLDS IN
SKIRT

FRONT OF
SHOE
CAN
HAVE
DIFFERENT
TONE

LEG
SHOWS THROUGH
HOLE IN SKIRT

EYES

MOUTH

NOSE

THE PRINCESS SNOW WHITE HAS A NATURAL SWEETNESS OF TEMPERAMENT WHICH ENDEARS HER TO EVERYBODY — EVEN TO GRUMPY.

"DOC"

-DOC-

ROUND
FLUFFY
BEARD

HAT
UP

SHOULDERS
FAIRLY
PROMINENT

NO
NECK

BULGE

WEIGHT
HIGH

LOW
BELT

3 1/4 HEADS

—THO' BIG— HE IS
A VERTICAL
CHARACTER—HE IS
THE ONLY ONE WITH
SLEEVES ROLLED.

NOSE SHORT AND
FAT - EYES SMALL -

CLOTHES REACTING →
GLASSES NICELY
SITUATED ON NOSE -

DOC LOOKING OVER
GLASSES IS A GOOD
CHARACTER TOUCH.

JOWLS ARE
HANGY AND HEAVY

DOC, THE SELF-
APPOINTED LEADER,
OVER-GRACIOUS AND
POMPOUS, ALWAYS
GETS HIS WORDS AND IDEAS
MIXED. — THINKS HE'S
EFFICIENT BUT LOSES HIS
HEAD IN AN EMERGENCY. —

—"GRUMPY"—

— GRUMPY —

SHOULDERS
AND
CHEST
HIGH →

FIGURE CHANGES TO
DIFFERENT SHAPES CHARACTERISTIC
OF A GRUMPY ATTITUDE —

NOTE: PATCH ON ELBOW
OF SLEEVE AND A POCKET
ON COAT —

DEFINITE LINE
FROM NOSE TO
CORNER OF MOUTH

NOSE LARGE AND RATHER
HIGH ON HEAD —
SLIGHTLY BUSHY EYE-BROWS

BOW LEGS AND
SLIGHT BAG
IN PANTS —

GRUMPY, A BORN LEADER, IS PESSIMISTIC, DISTRUSTFUL, AN AVOWED WOMAN-HATER, YET, MUCH TO HIS DISGUST, HE HAS A VERY SOFT HEART WHICH HE CONCEALS WITH A SCOWL. WHEN TROUBLE ARISES, IT IS GRUMPY WHO ACTS FIRST. —

"HAPPY"

-HAPPY-

TILT ON HEAD IS
CHARACTERISTIC

VEST WITH LARGE
BUCKLE ON BELT
BAGGY PANTS

WIDE HIPS
WITH LEGS
COMING TOGETHER
AT FEET —

HAT UP

FLUFFY BEARD—
FOLLOWS JOWLS
HANGS OVER
CHEST

SHOULDERS
SLOPE AND
LOW

NO NECK

HIGH BELT

TOES OUT

WEIGHT
LOW—
LEGS CUT
IN FAST

3 HEADS

CHEEKS REACT
TO MOUTH—

FLUFFY WHITE
EYE-BROWS
FOLLOW EYES—

Happy is the fat roly-poly little fellow with a ready smile and a cheery voice. — Troubles sit lightly on him for he always detects the silver lining.

"BASHFUL"

-BASHFUL-

ARMS JOIN BODY
RATHER HIGH -
PRACTICALLY NO NECK-
LEGS SHORT AND FAT-
SWING IN BODY -
NOSE LOW ON HEAD-

VERY LARGE EYES
AND VERY PROMINENT
EYE LASHES —

CARRYING BASHFUL'S
NOSE LOW ON HEAD
MAKES HIM ALWAYS
LOOK UP OUT OF TOP
OR SIDE OF EYES

A MEREST GLANCE
FROM PRETTY SNOW WHITE
MAKES HIM TWIDDLE HIS BEARD—
RISE ON HIS TOES, TWIST HIS
ARMS & LEGS, SHUT HIS EYES.....
THE ONLY SOUND WHICH ES-
CAPES FROM UNDERNEATH
A VERY BLUSHING NOSE IS
AN EMBARRASSED: AW, GOSH!.....

—"SNEEZY"—

-SNEEZY-

SHORT STUBBY
BEARD - POINTED
AND RATHER STIFF

HAT
DOWN

SHOULDERS
SLOPE

HAS
NECK

WEIGHT
LOW -

BELT
LOW

SHORTEST
LEGS-STUBBY
AND BOWED-

3 HEADS

NOSE SHORT AND
SET HIGH ON HEAD —
EYES SMALL —
UPPER LIP LONG
LOWER LIP THICK
AND STICKS OUT

NOTICE UP-TURN ON NOSE —
— TEETH CAN HELP
GIVE SNEEZY LOOK —

SNEEZY, A VICTIM OF
CHRONIC HAY FEVER. —
TALKS WHEEZILY THROUGH
HIS NOSE. — HIS EXPLOSIVE,
ILL-TIMED SNEEZES PUNCTUATE
THE STORY LIKE PISTOL SHOTS —

"SLEEPY"

— SLEEPY —

NOSE SHORT AND STUBBY·
EYELIDS BIG AND HEAVY ·

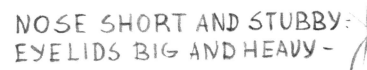

SLEEPY USUALLY
LEANS BACKWARD
OR FORWARD AL-
MOST OFF BALANCE.

"DOPEY"

— DOPEY —

DOPEY IS A
SHORT THREE HEADS
HIGH —

ONLY ONE WITHOUT
BEARD —

SMALL NOSE —
HAT MUCH TOO BIG —

GET
DROOPY
EFFECT IN
ALL
CLOTHING

-AND CAN FLOP AROUND
ON HEAD —
EARS AWFULLY BIG

AND EYES ARE
A TRIFLE SLANTED

NOTICE
CLOTHING
MUCH TOO
BIG FOR
HIM

DOPEY, LOVABLE, SLIGHTLY
BACKWARD, HAS NEVER
LEARNED TO TALK. —
THE DWARFS TREAT HIM
AS THEIR DRUDGE. —
GRINS WISTFULLY WHEN-
EVER SNOW WHITE ADDRESSES
A KIND WORD TO HIM. —
ONE OF LIFE'S MISFITS
FOR EVER OUT OF STEP ——

"THE QUEEN"

WELL CURVED EYEBROWS
COMING LOW DOWN
TOWARDS CENTRE
OF FACE.
PROMINENT EYELASHES.
HIGH CHEEKBONES.

THE QUEEN — PROUD
DISDAINFUL, HAUGHTY.
CONSCIOUS OF HER
BEAUTY ————————
FIERCELY JEALOUS
OF SNOW WHITE.

"THE WITCH"

"BOIL....BOIL.....BOIL...."

THE WITCH — THE EMBODIMENT OF THE WICKED QUEEN'S SINISTER NATURE.

"THE PRINCE"

PRINCE
COSTUME

PATTERN COLLAR
FOR ANIMATION
AND SOLIDITY

FEEL FOLDS
AROUND
CAPE STRAPS

FEATHER IN
BROAD LINE
TREATMENT

BROADEN
SHOULDERS
WHEN IT
SEEMS
TO HELP
FIGURE

CENTER
BELT
BUCKLE

BOTTOM
OF VEST
DROPS
BELOW
CROTCH

FEEL
THICKNESS
IN FOLD
OF SHOES
GOING AROUND
CALF —

PRINCE MODELS

BUILD OUT BROW.
EYELASHES HEAVIEST
TOWARD OUTSIDE. —

EYEBROWS ARE THICKER
IN THE HALF TOWARDS
THE CENTRE OF
FACE. — SMILE DIMPLE
ON NEAR CHEEK ONLY.

TILT NOSE UPWARDS
FROM BASE. — GET
UPWARD CURVE TO CORNER
OF MOUTH IN SMILE.

THE PRINCE — A
CHEERFULL YOUTH—
ADVENTUROUS, BRAVE
AND CHIVALROUS —

"THE HUNTSMAN"

A GOOD-HEARTED FATHERLY SOUL WITH THE LOYALTY OF A FAMILY RETAINER. — — BUT WHEN THE QUEEN COMMANDS HIM

TO KILL
SNOW WHITE
HIS CONSCIENCE
FORBIDS HIM TO
OBEY HER
CRUEL ORDER

—ANIMALS—

BIRD MODELS

BABY

MOTHER

FATHER

—CHIPMUNKS—

RACCOON AND
TURTLE
MODELS. —

— BEDROOM DOOR —

— INTERIOR
STUDIES —